Decorative Flower and Leaf Designs

by Richard Hofmann

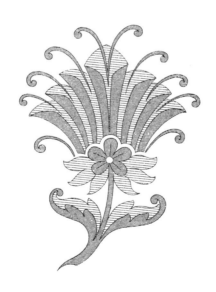

DOVER PUBLICATIONS, INC.
New York

Decorative Flower and Leaf Designs, first published by Dover Publications, Inc., in 1991, is a new selection of motifs from the portfolio *Blätter und Blumen für Flächen-Decoration: Eine Vorlagensammlung für Zeichen-, Webe- und gewerbliche Fortbildungsschulen, Fabrikanten und Musterzeichner*, originally published by E. Twietmeyer, Leipzig, 1885. A new Publisher's Note has been written specially for the Dover edition.

DOVER *Pictorial Archive* SERIES

Manufactured in the United States of America
Dover Publications, Inc., 31 East 2nd Street, Mineola, N.Y. 11501

Library of Congress Cataloging-in-Publication Data

Hofmann, Richard, of Plauen im Vogtland.
 Decorative flower and leaf designs / Richard Hofmann.
 p. cm. — (Dover design library)
 "A New selection of motifs from the portfolio Blätter und Blumen für Flächen-Decoration . . . originally published . . . 1885"—T.p. verso.
 ISBN 0-486-26869-1
 1. Decoration and ornament—Plant forms. 2. Flowers in art. 3. Leaves in art.
I. Hofmann, Richard, of Plauen im Vogtland. Blätter und Blumen für Flächen-Decoration. Selections. II. Title. III. Series.
NK1560.H57 1991
745.4—dc20
 91-11924
 CIP

Publisher's Note

THE ADVANCES IN MANUFACTURING that occurred in late eighteenth-century Europe as a result of the industrial revolution were followed by a rapid succession of improvements in textile machinery, lowering production costs and creating a new and expanding market for cloth products of all kinds. The demand for textile designs increased accordingly, not least in the technical schools. Richard Hofmann's portfolio of leaf and flower designs *Blätter und Blumen für Flächen-Decoration*—of which the 124 illustrations in the present volume are a substantial selection—was first published in Leipzig in 1885 to serve this demand, offering simple and attractive forms suitable for manufacturers, designers and craftspeople. These designs were originally intended for a wide range of uses, from hand and machine stitching to stenciling, on materials such as leather, silk and lace. Although Hofmann asserts in his "Vorwort" that the designs chosen reflected contemporary trends rather than turning to the art of past epochs, the style bears a marked resemblance to the woven fabric patterns of the early northern Renaissance.

To facilitate their use by the modern artist or designer, the frames originally surrounding each design have been deleted in the present edition.

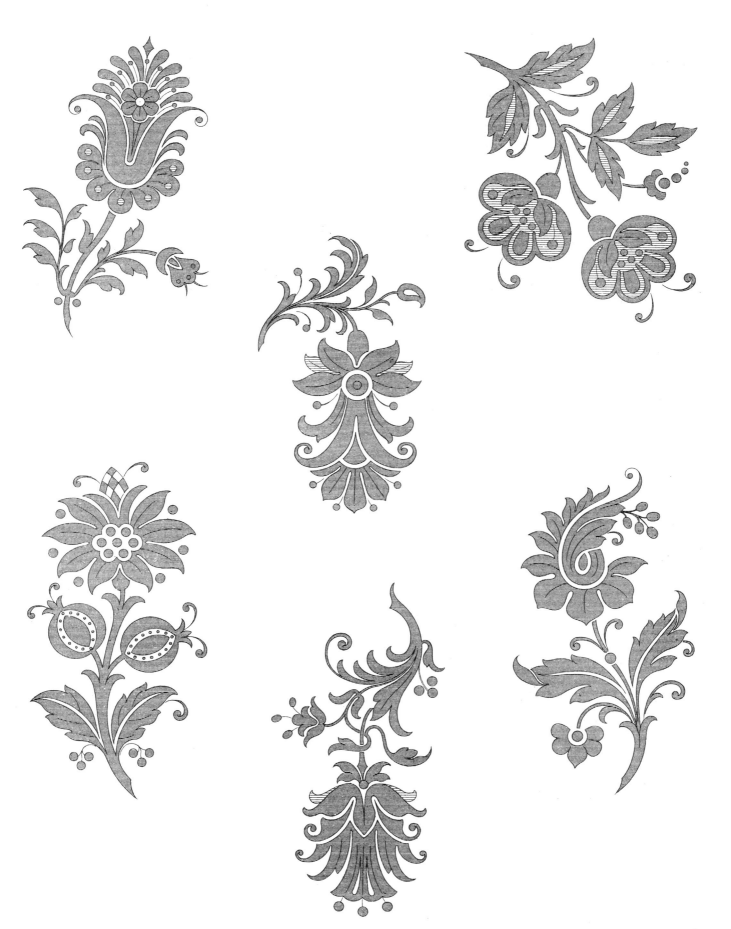

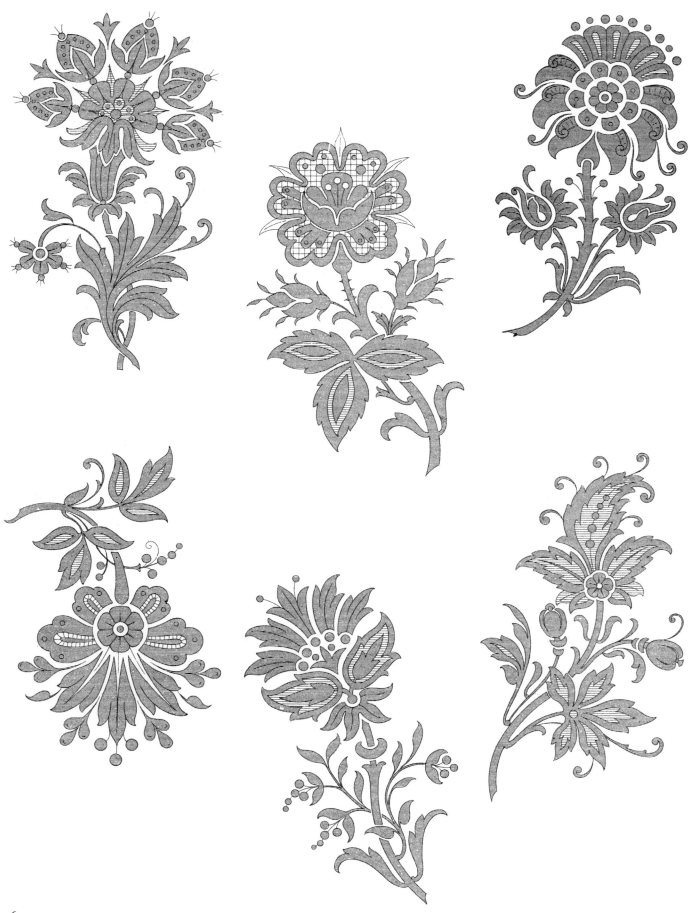

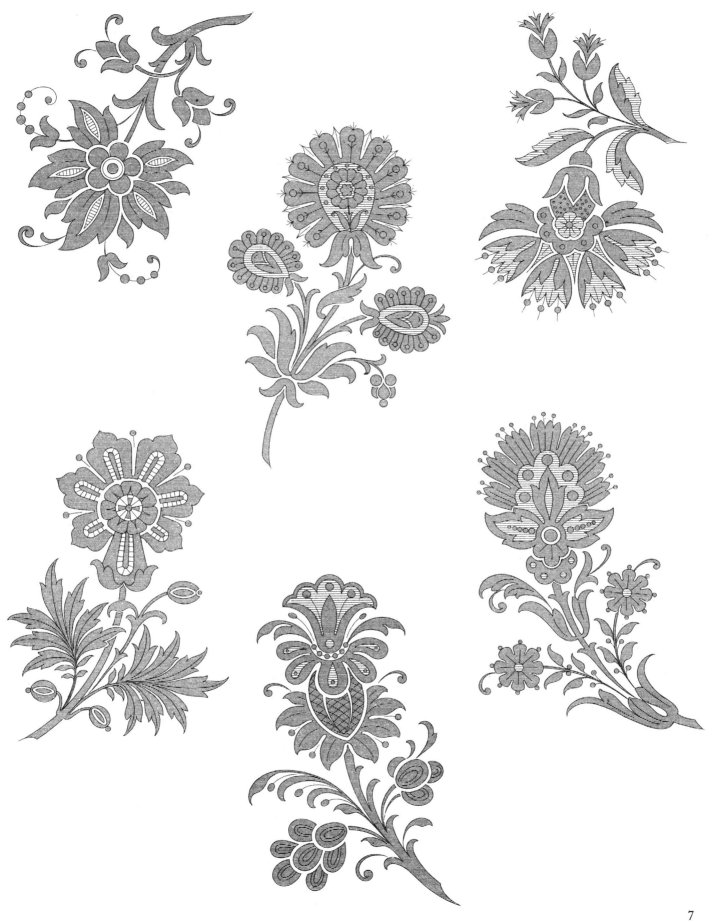

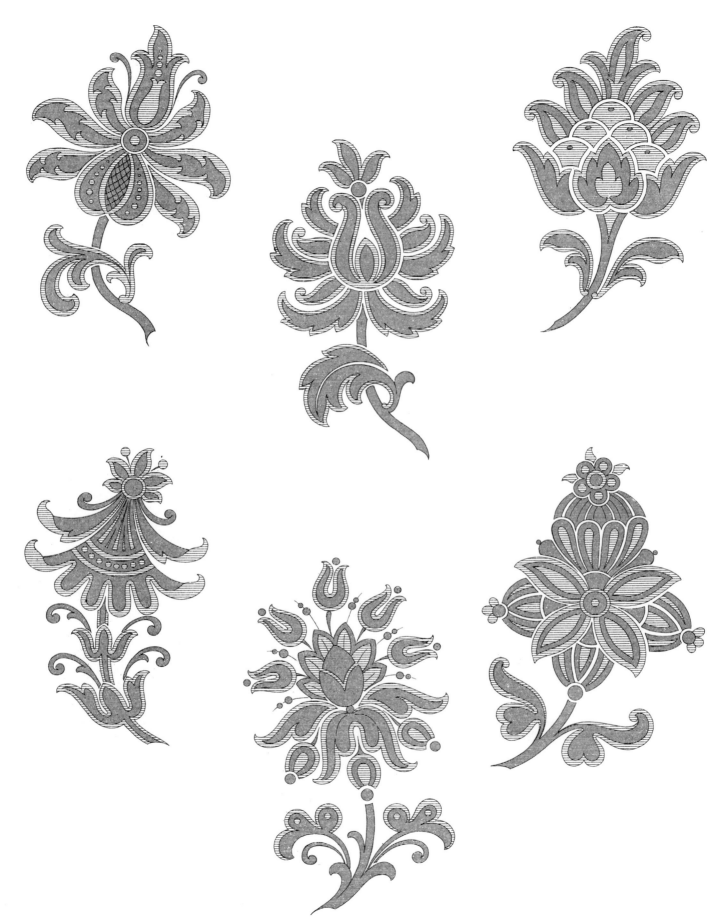

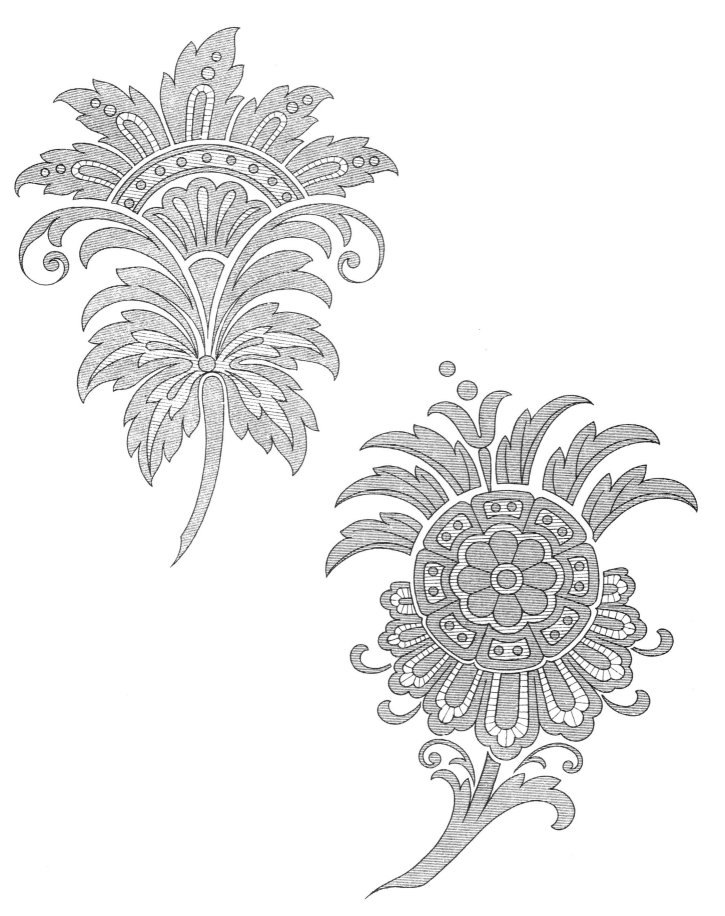

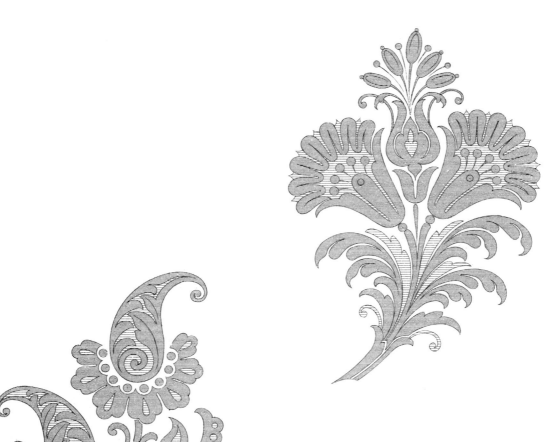

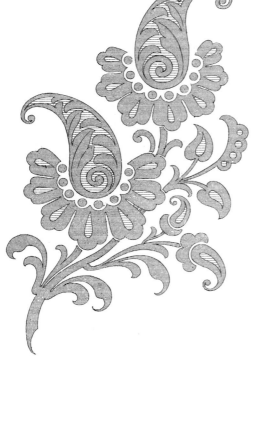

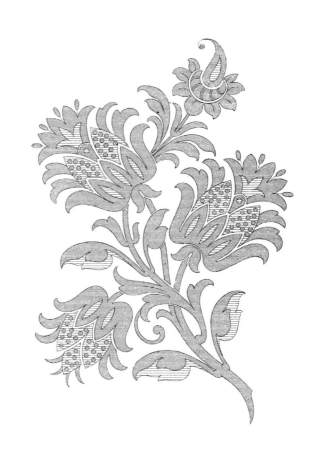

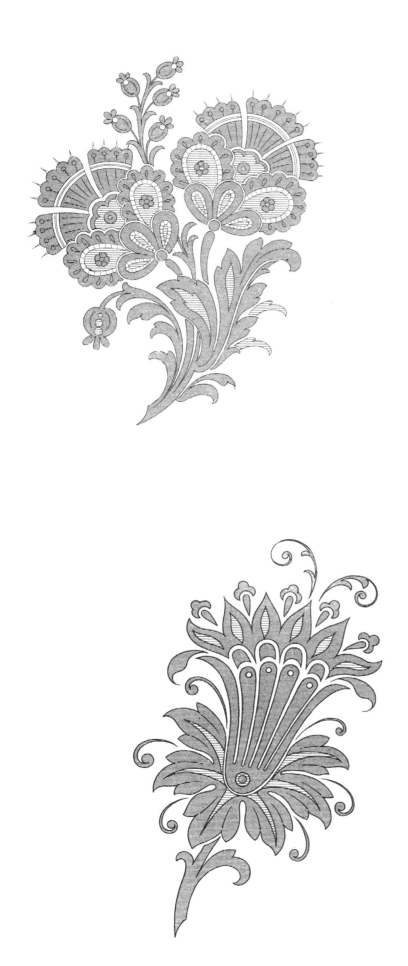
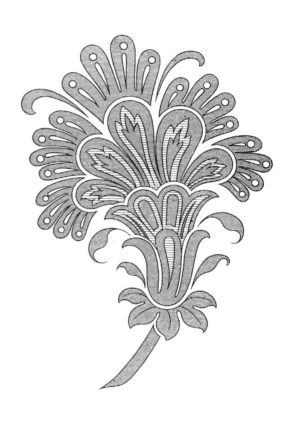

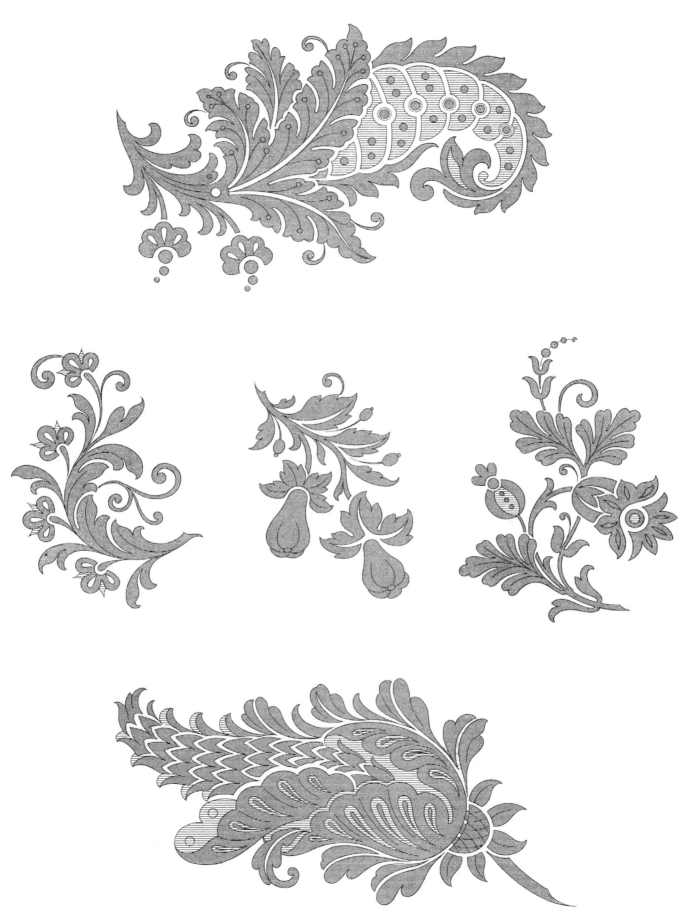

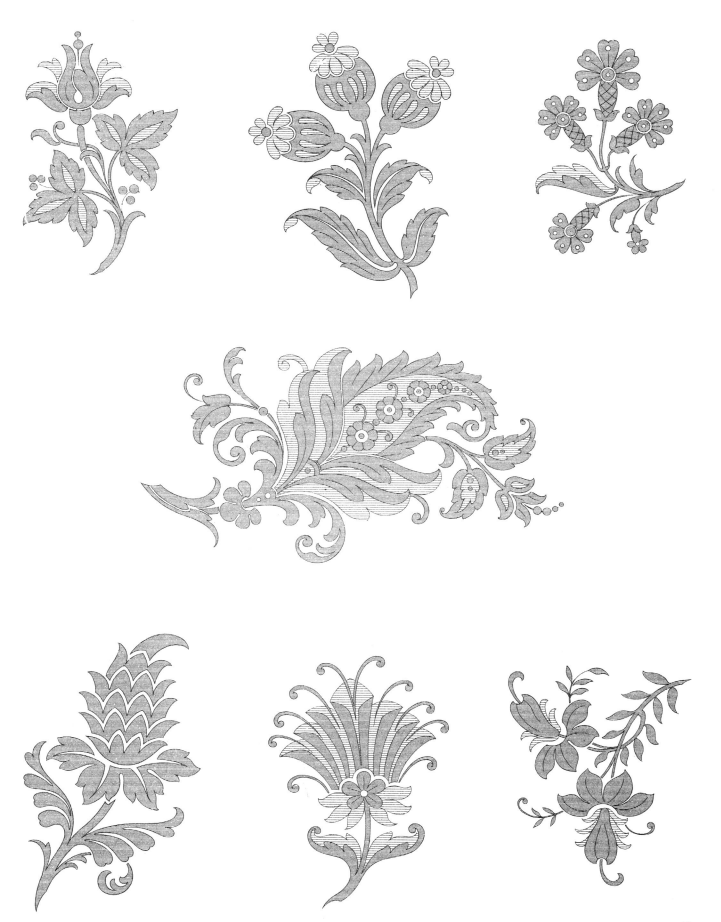

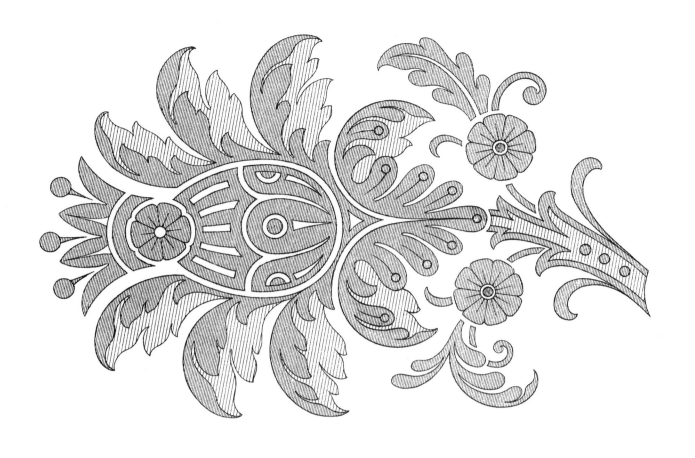

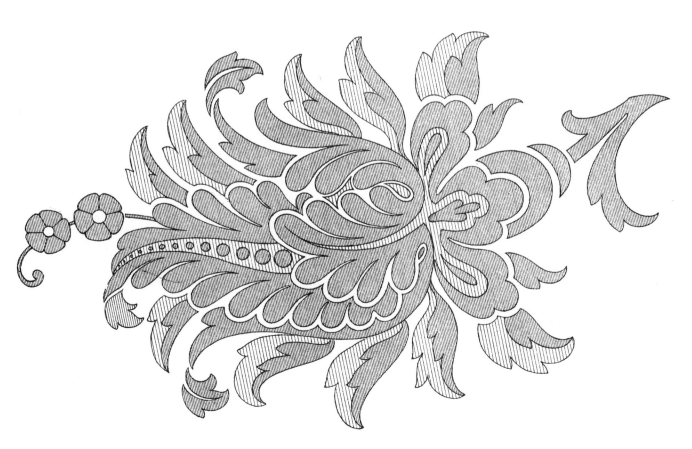

14

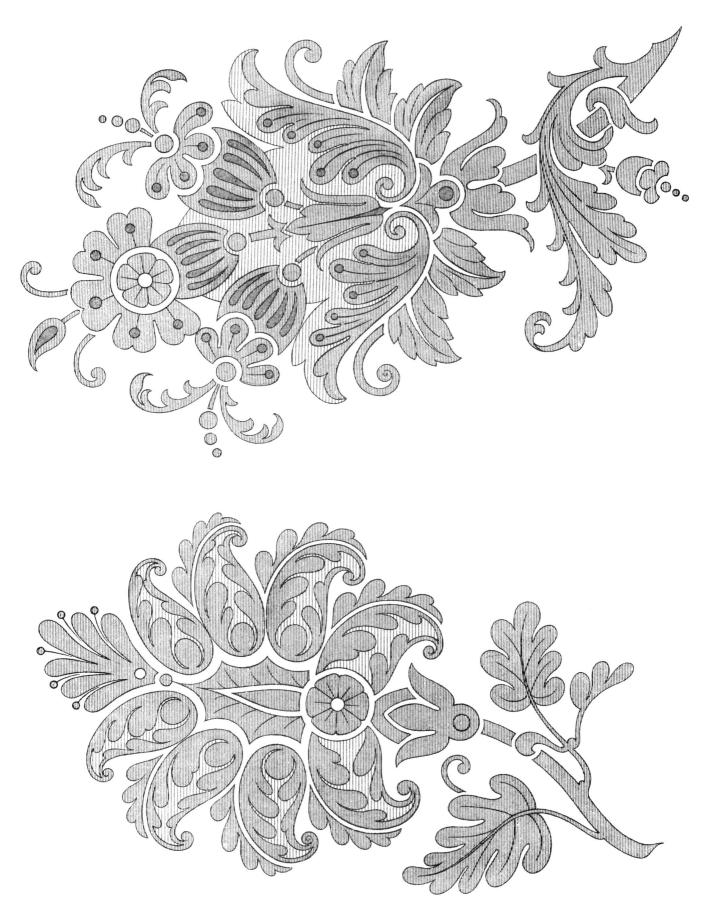

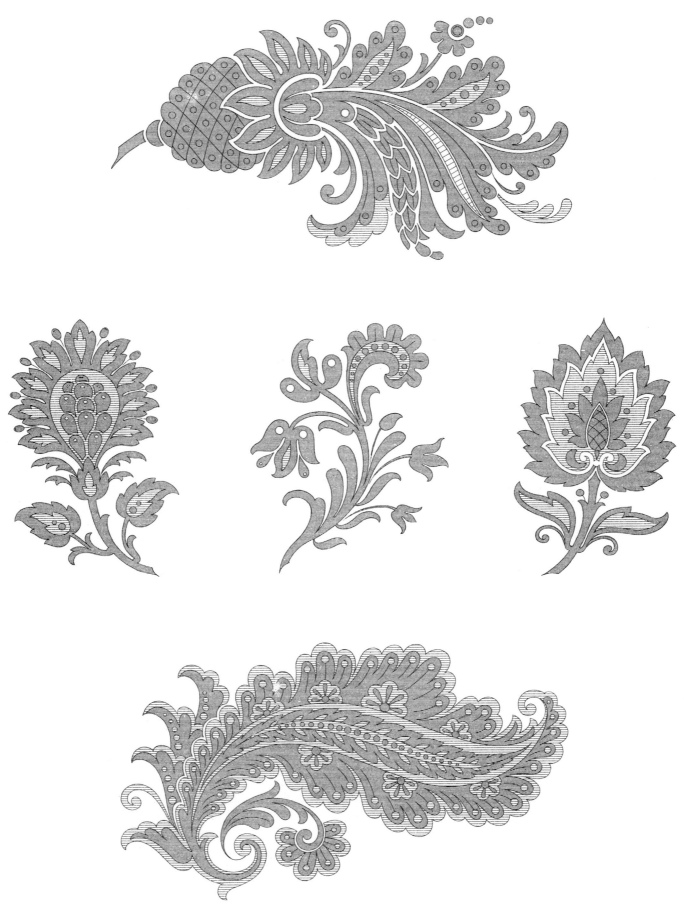

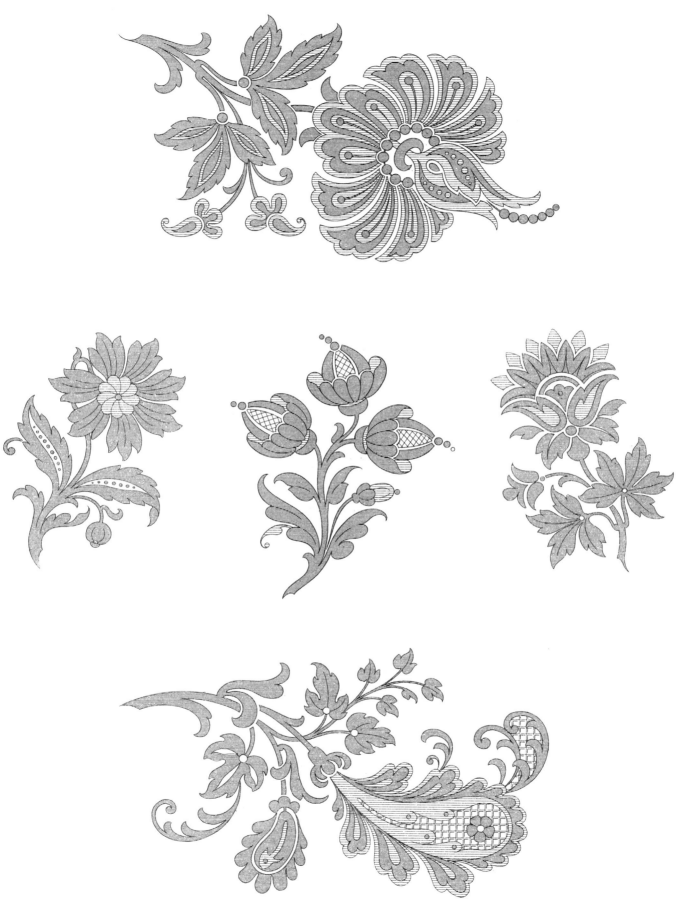

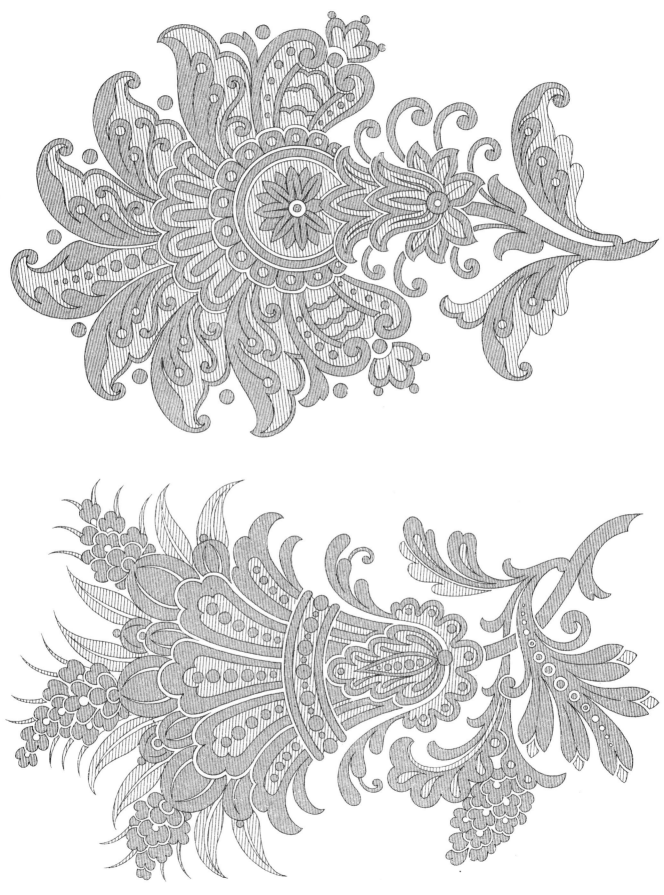

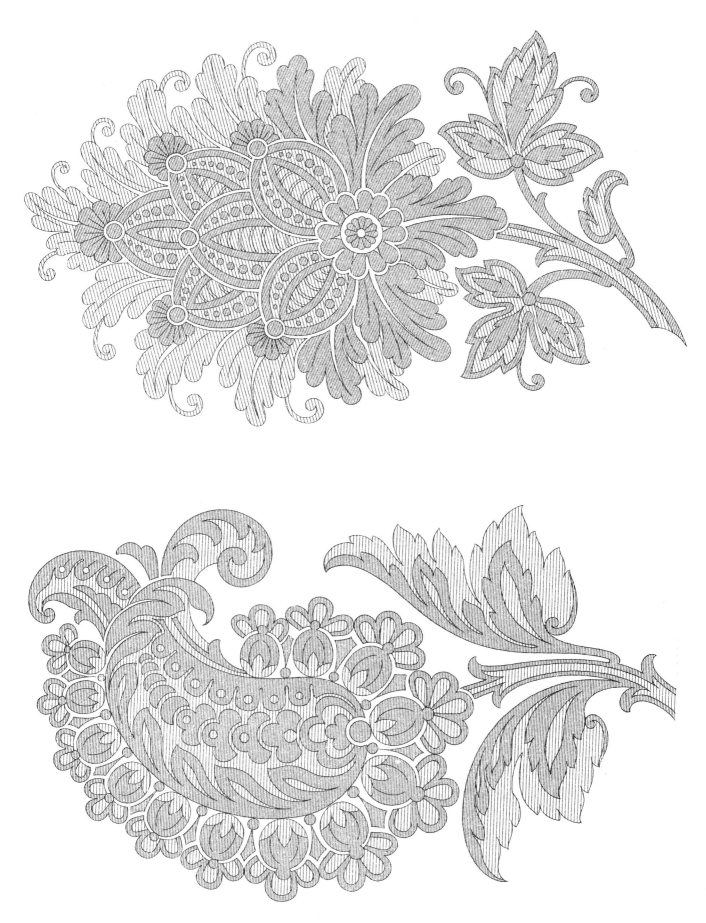

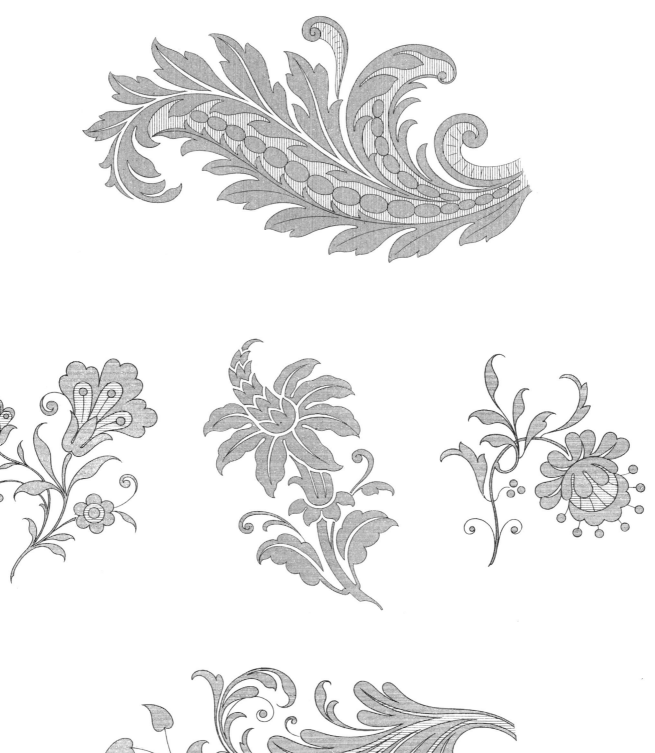

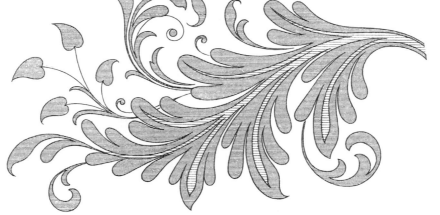

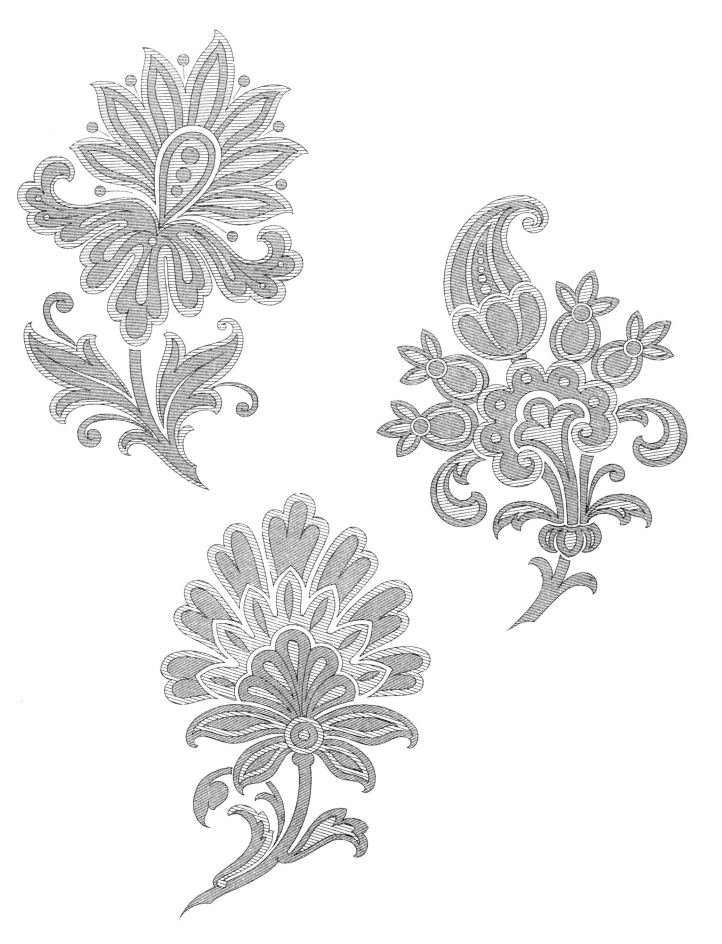

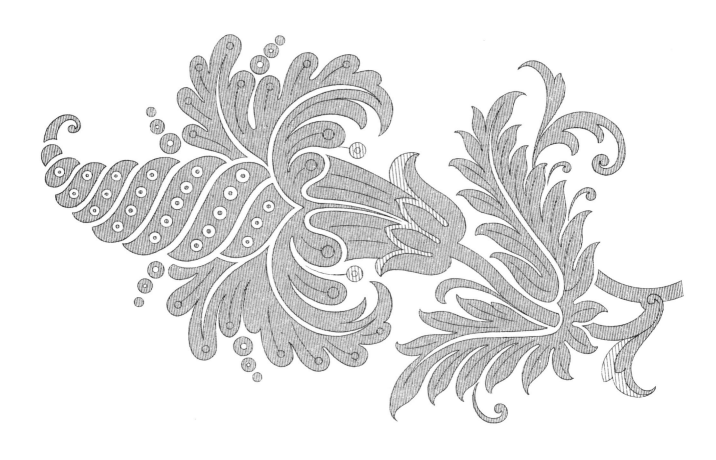

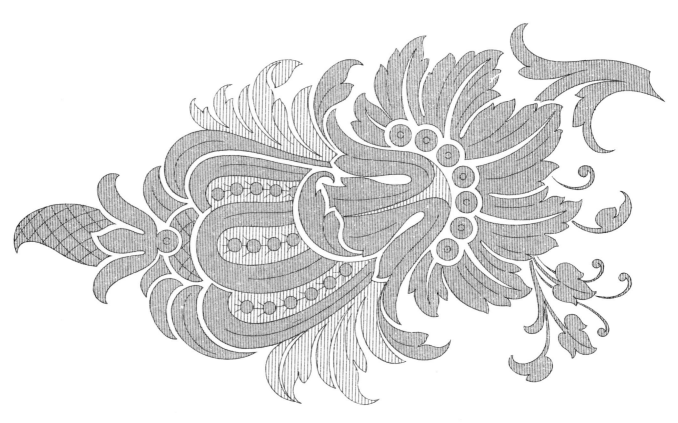

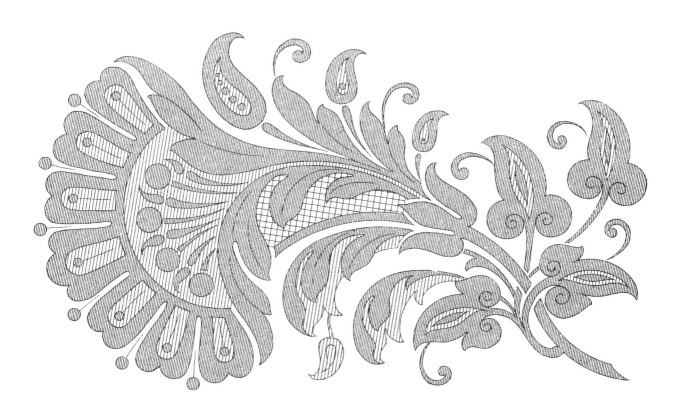

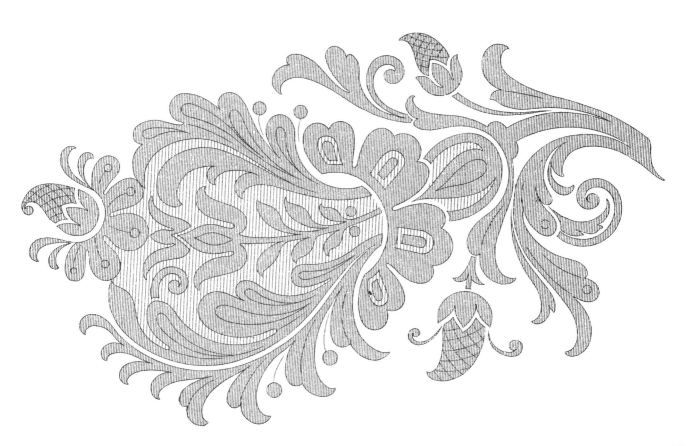

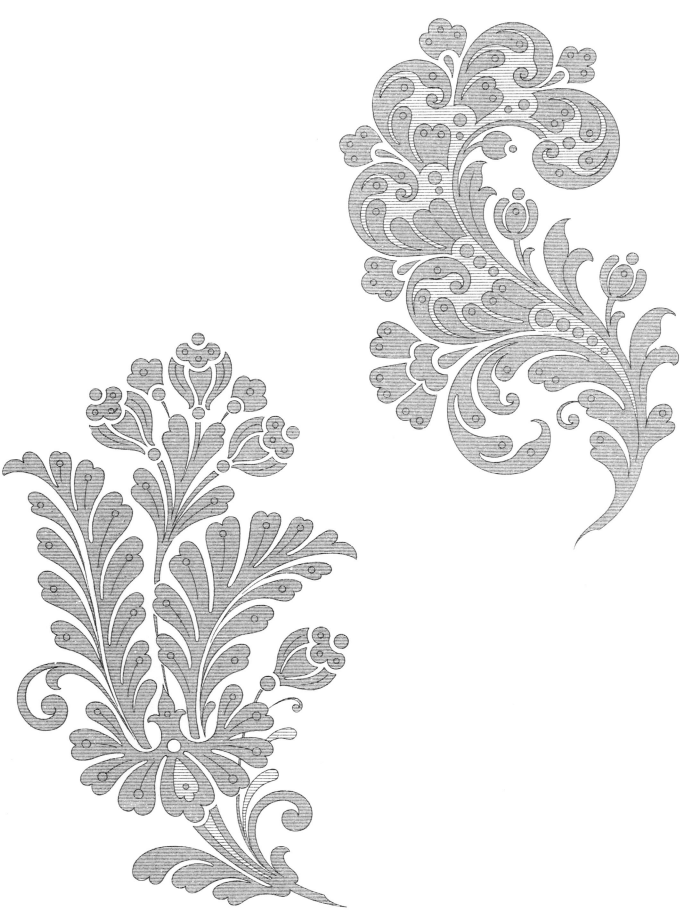

24

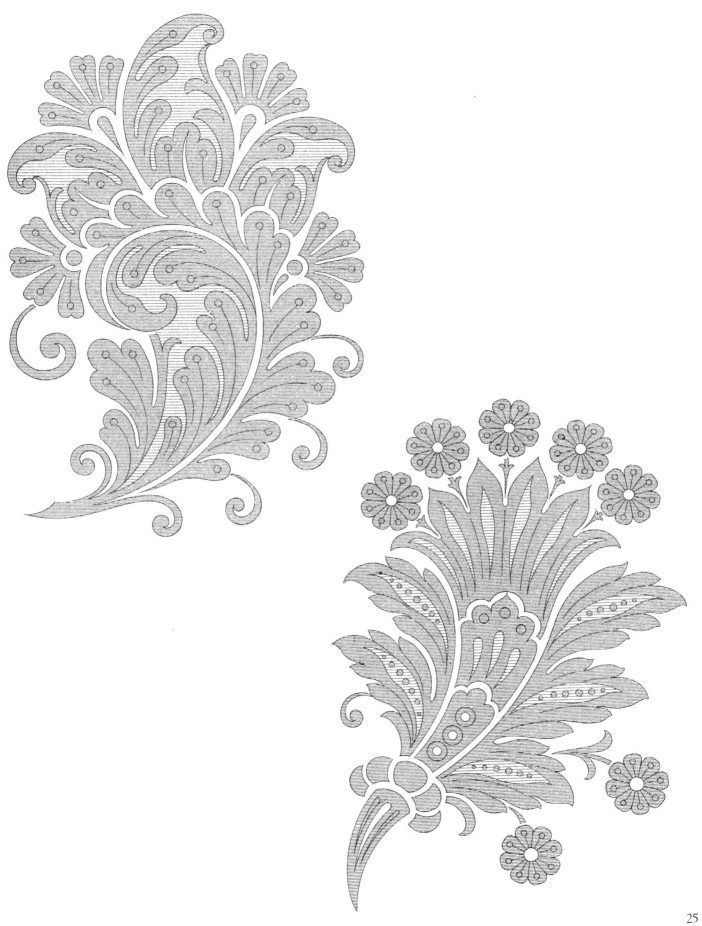

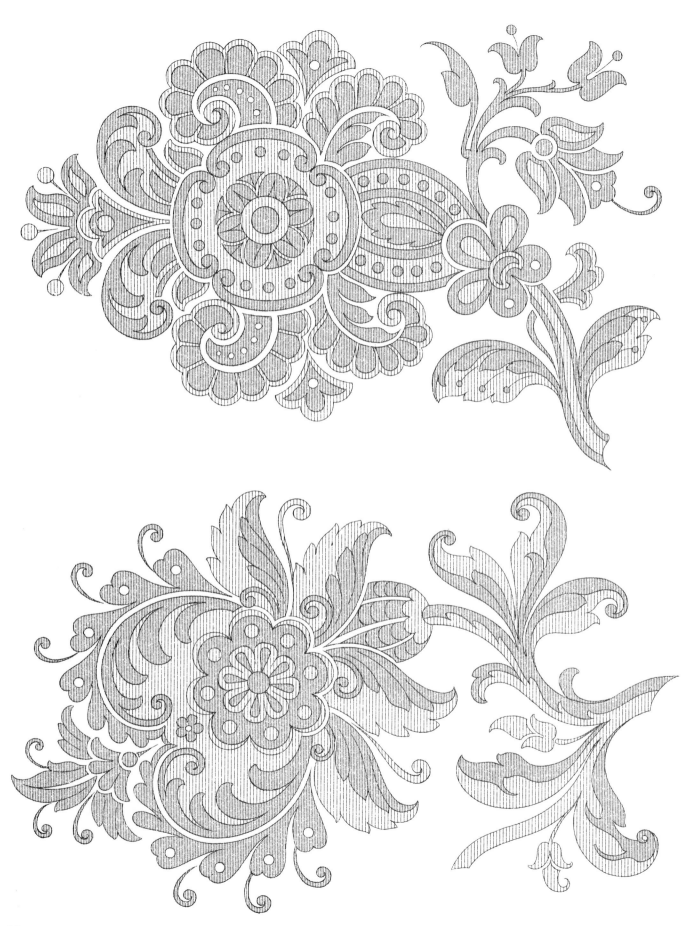

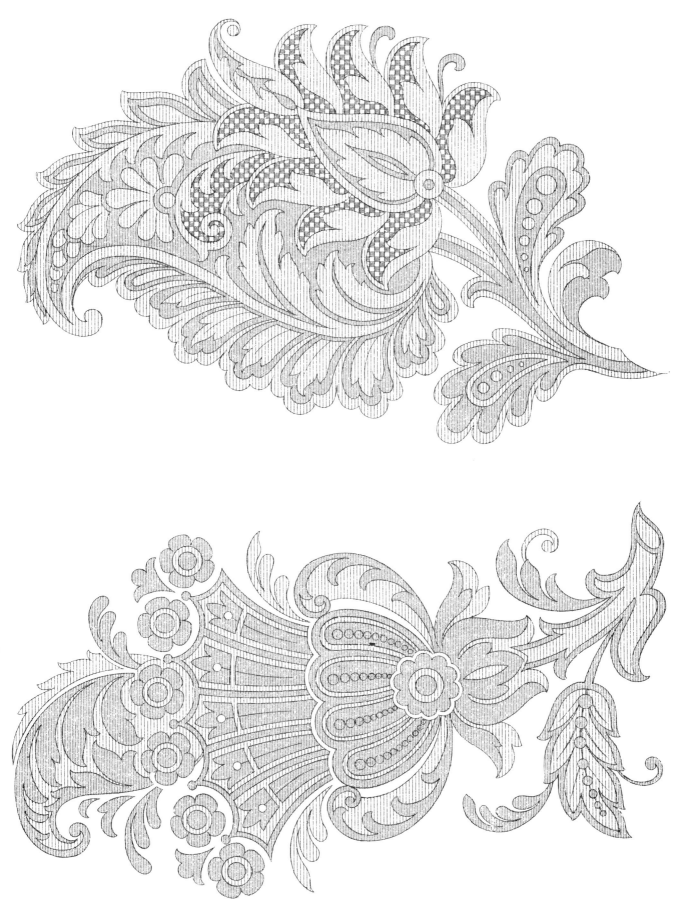

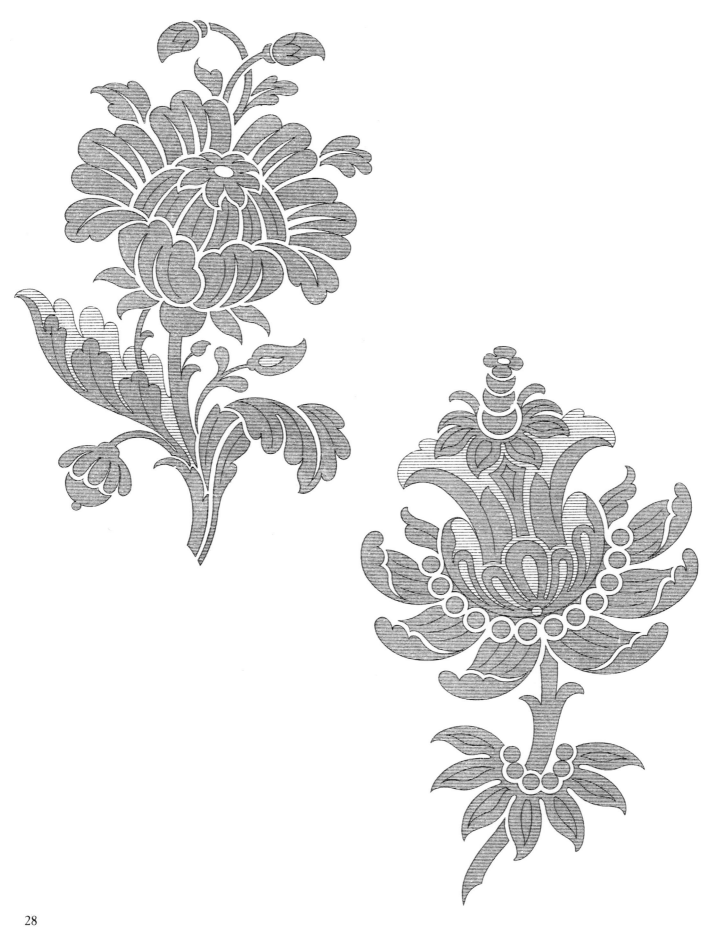

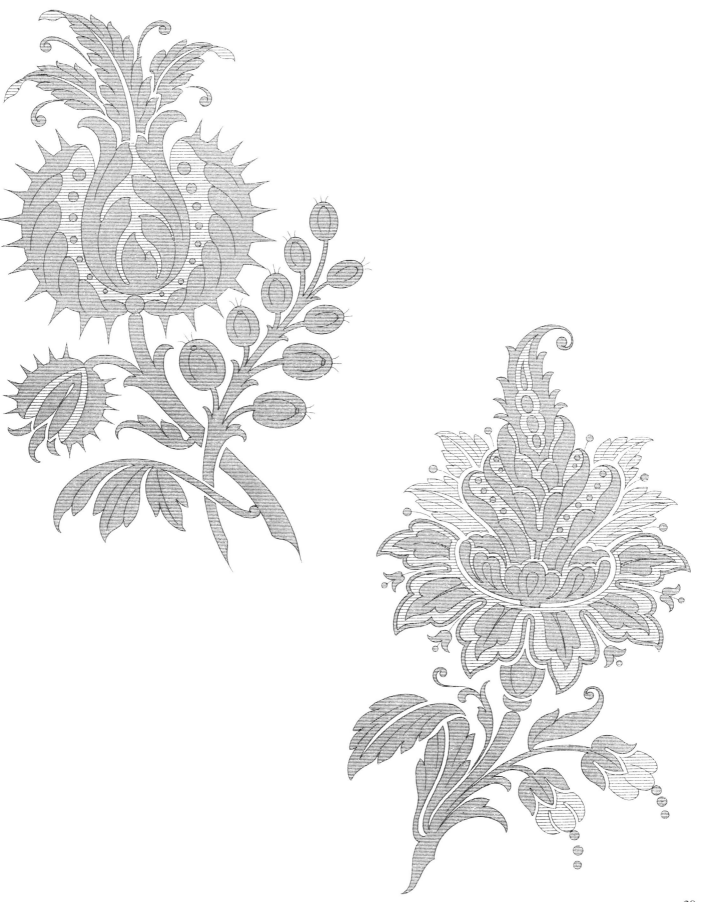

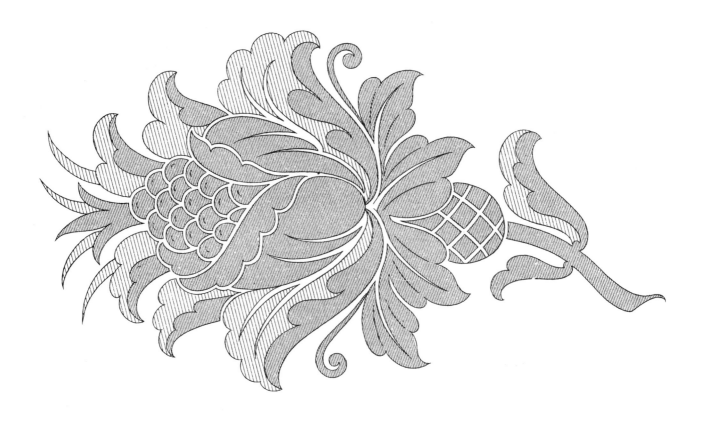

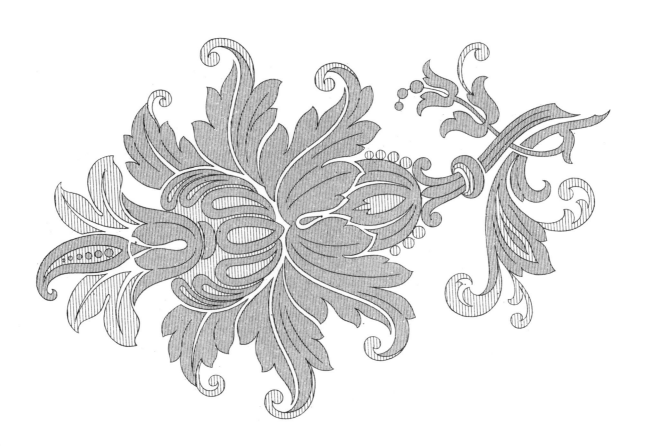

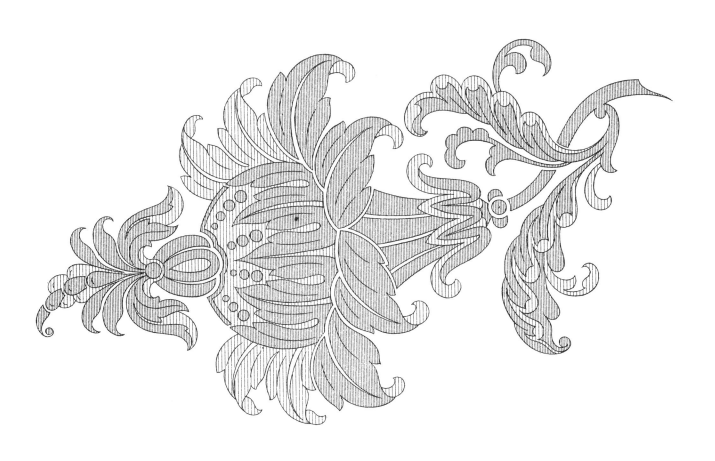

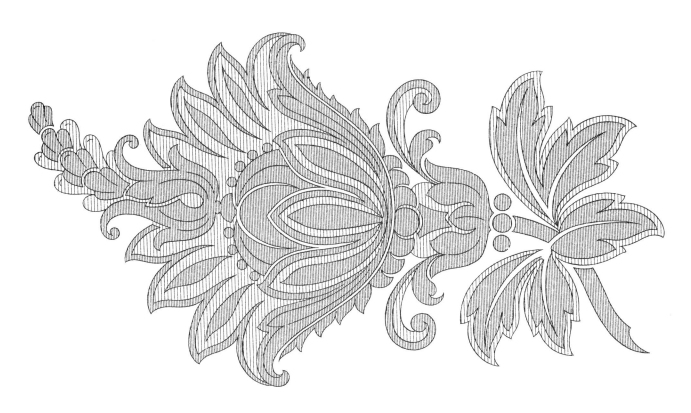

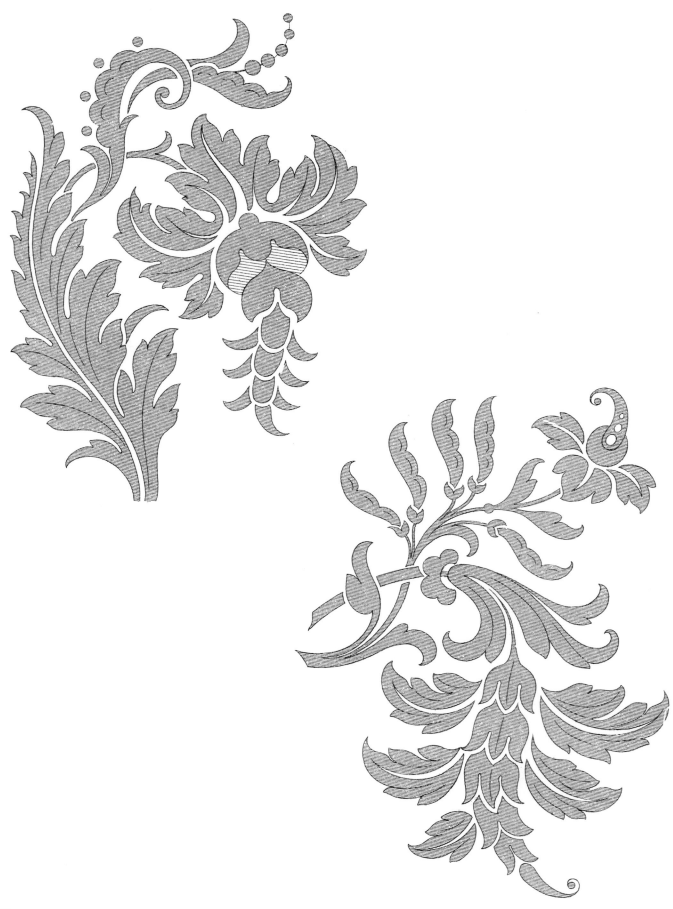

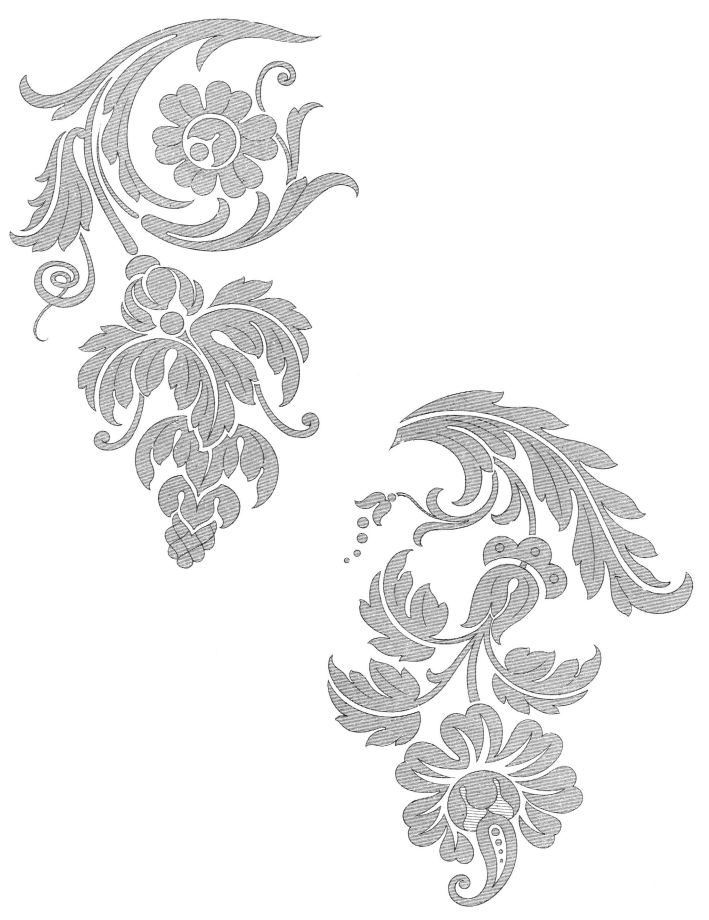

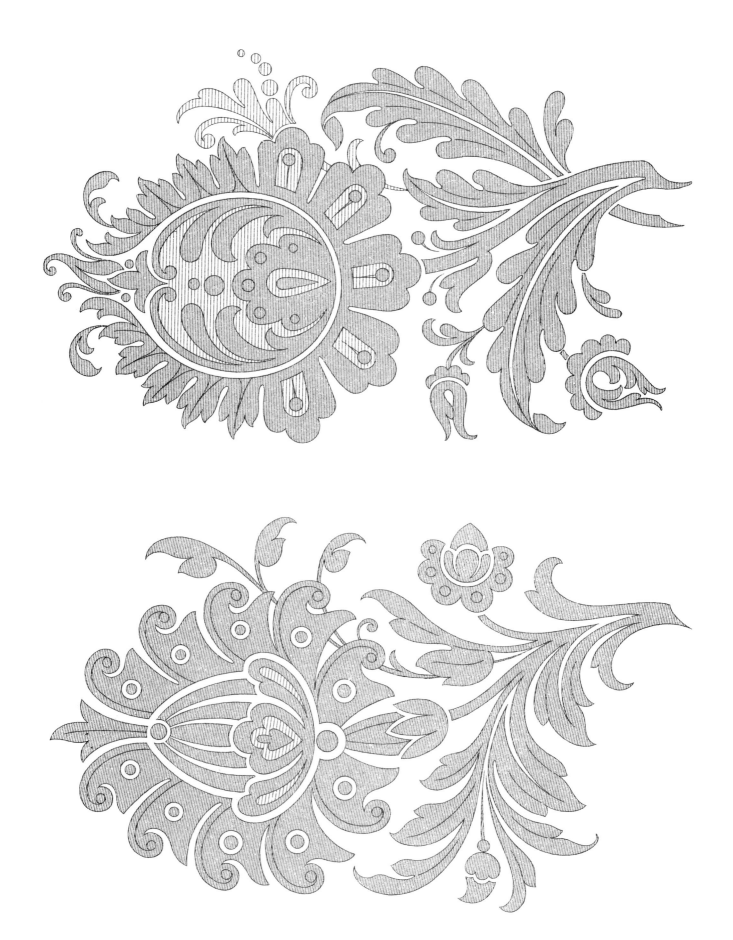

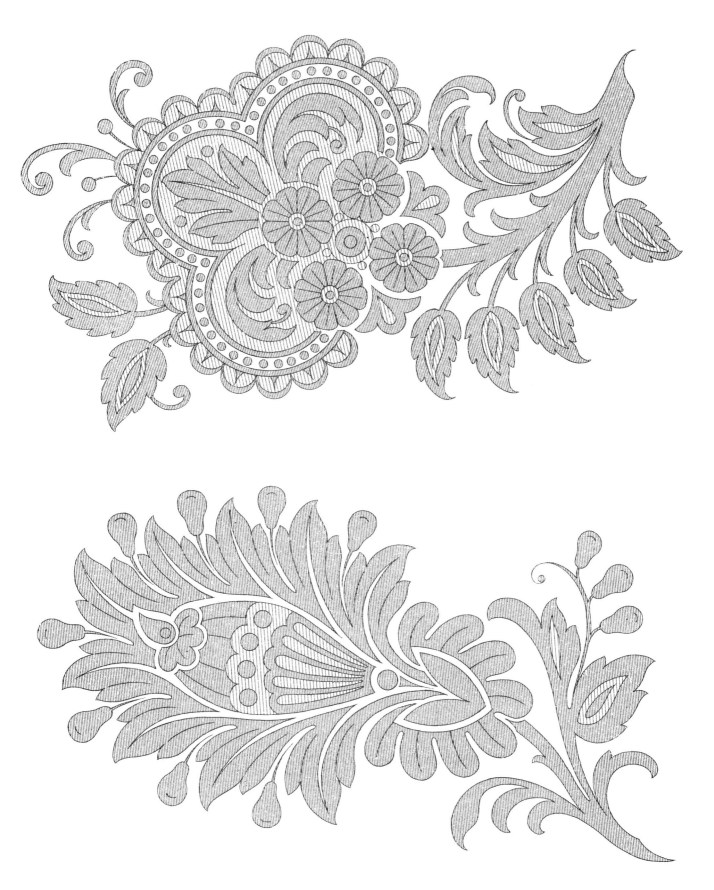

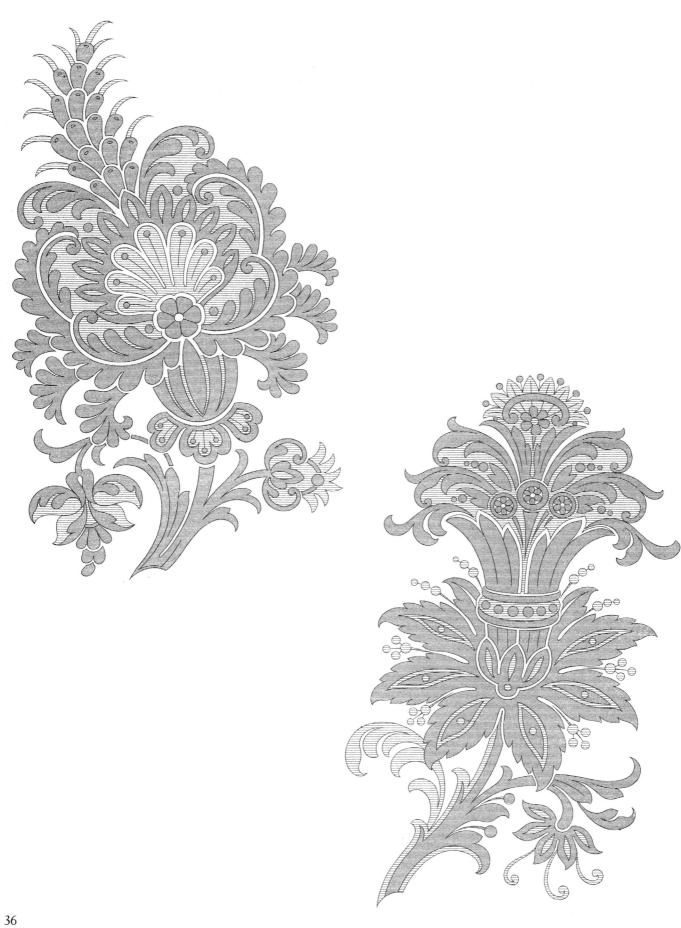

36

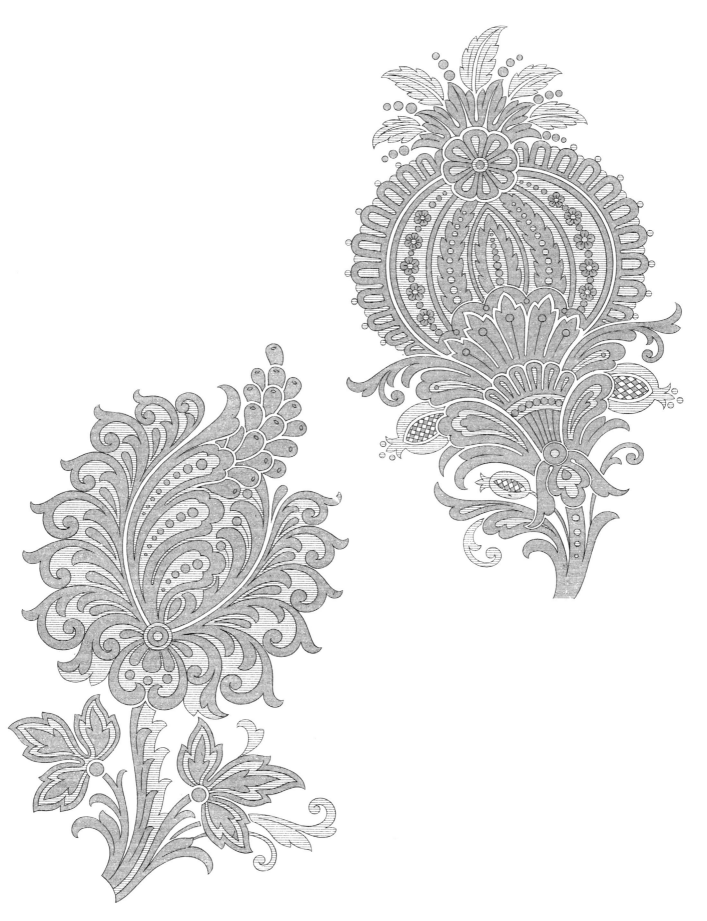

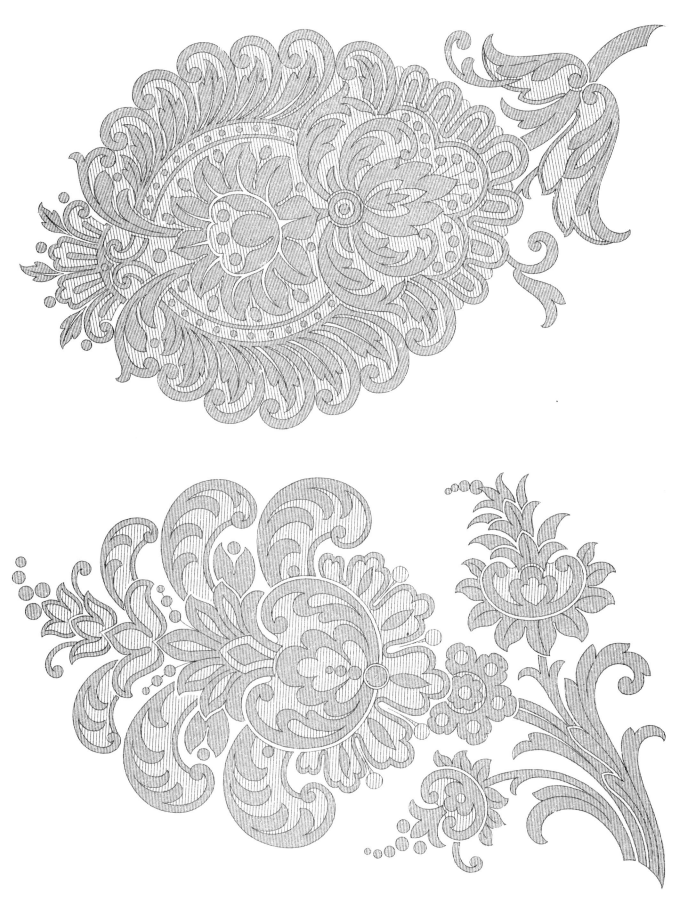

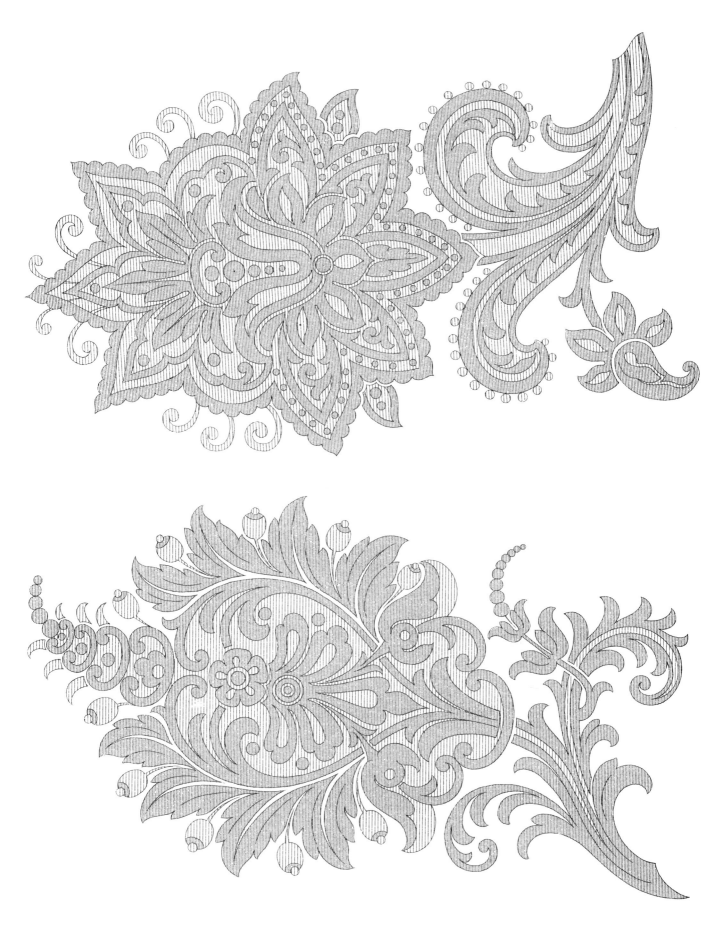

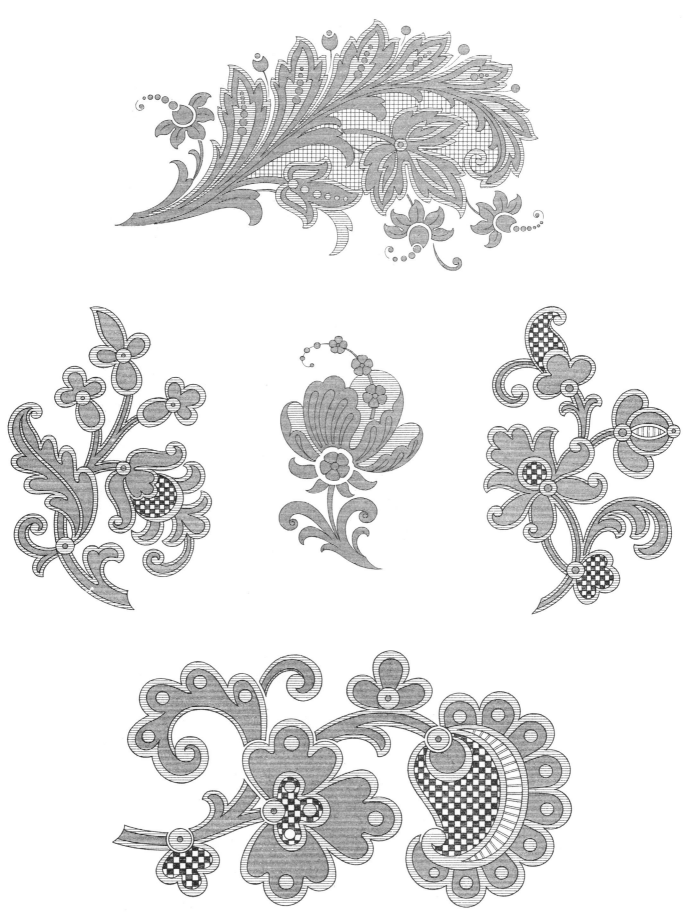

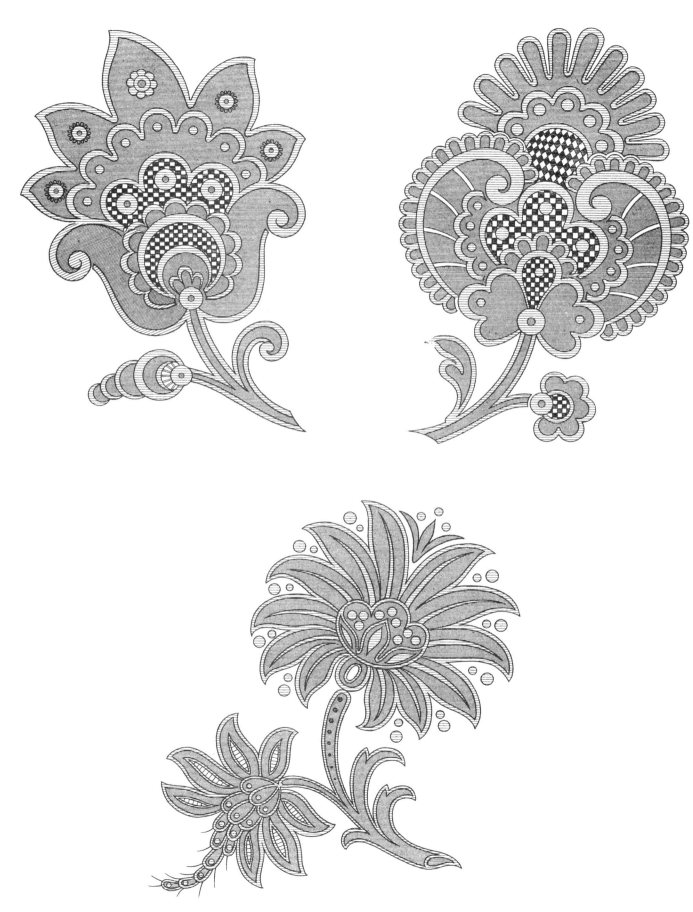

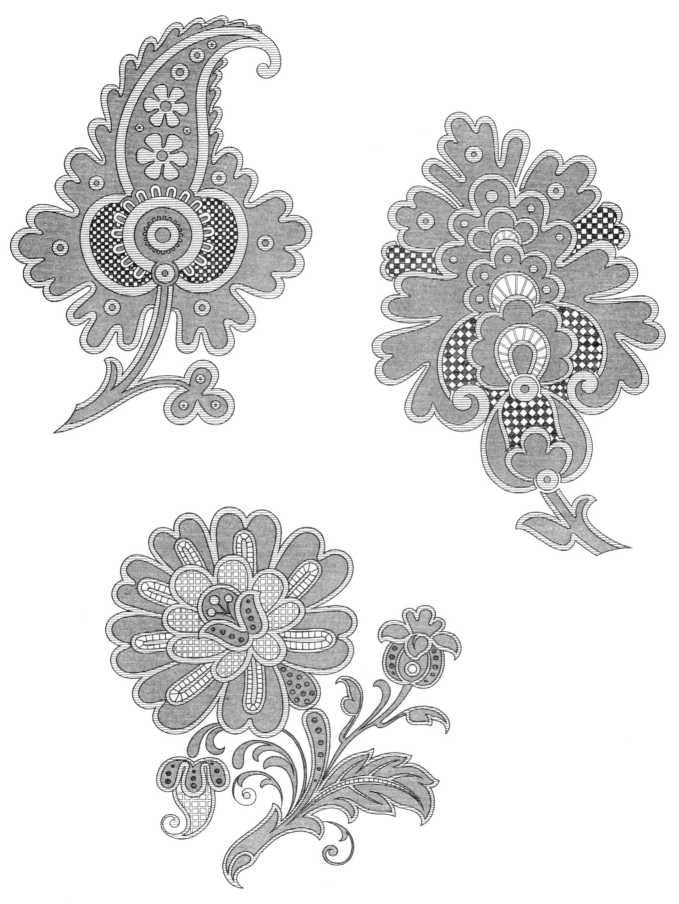

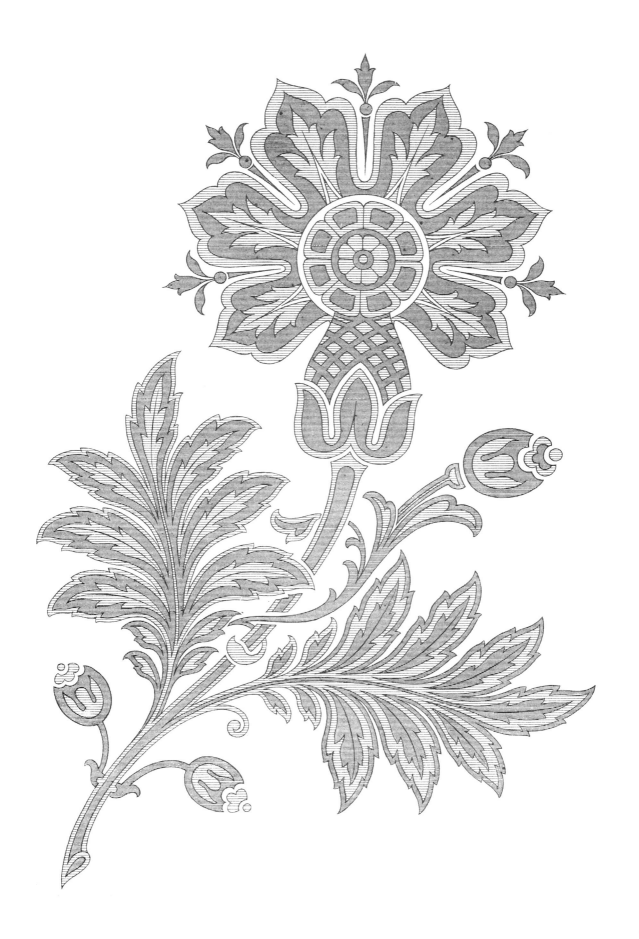

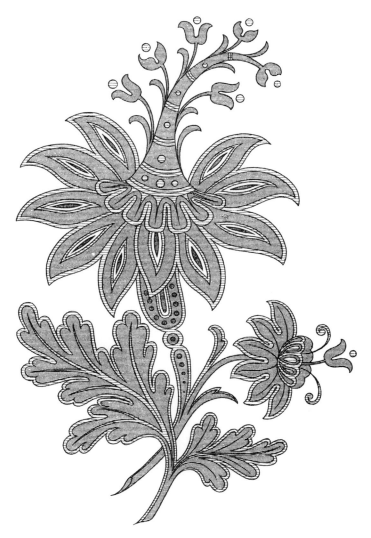
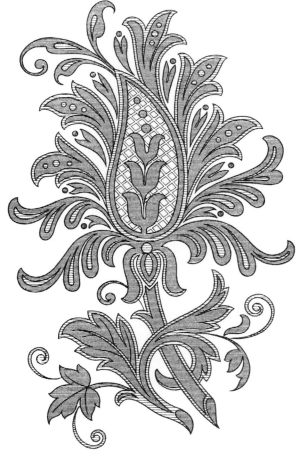

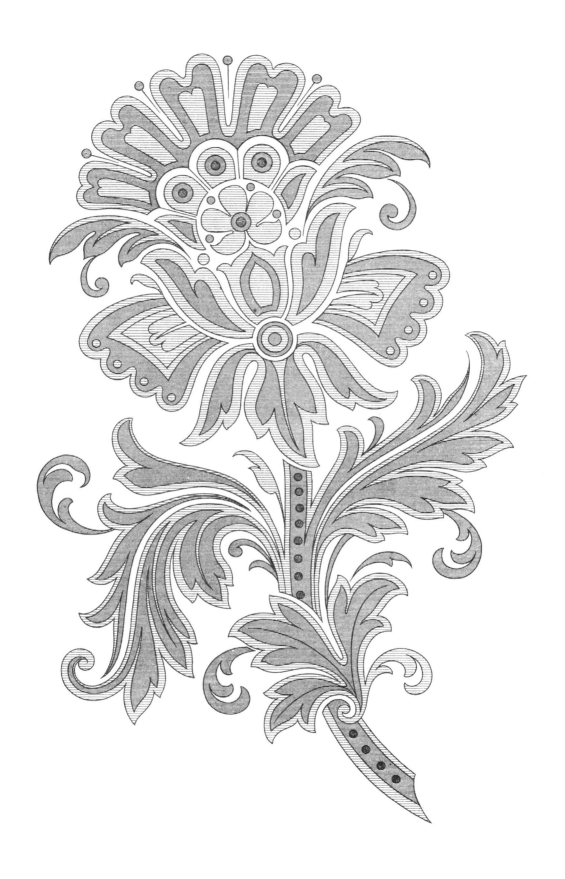

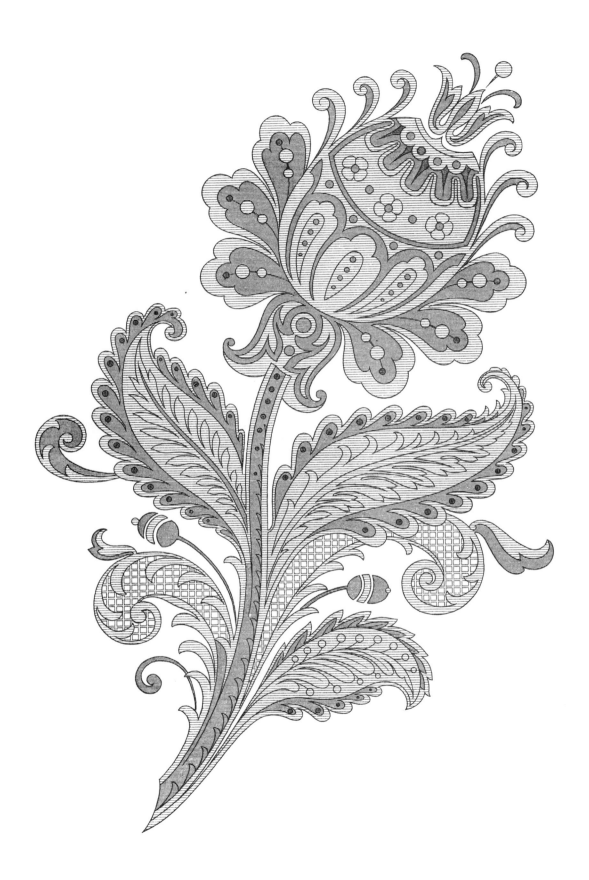

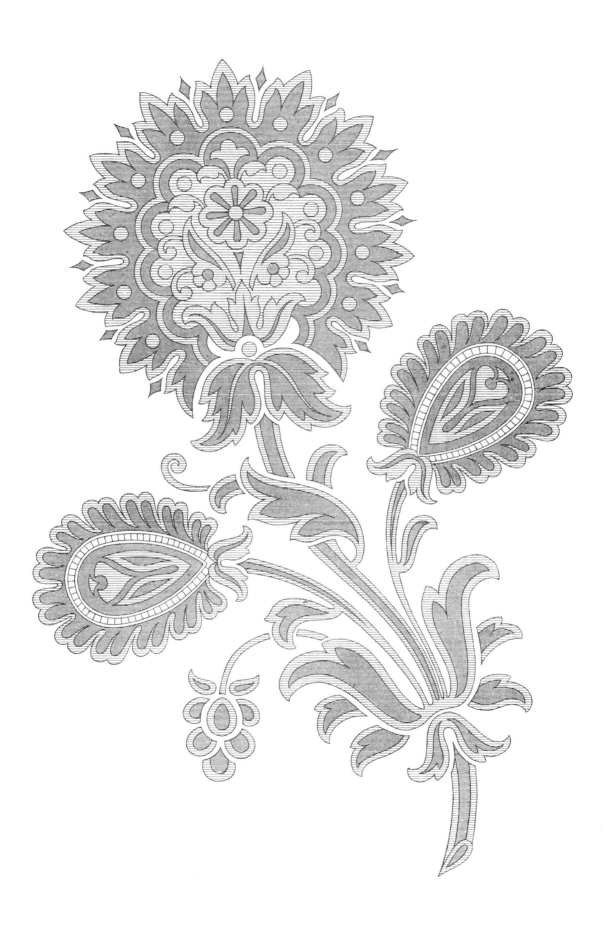